THIS CANDLEWICK BOOK BELONGS TO:

PANDA

For PR
J. A.
For Theo
T. H.

The author and publisher wish to thank
Martin Jenkins for his invaluable assistance
in the preparation of this book.

Text copyright © 1992 by Judy Allen
Illustrations copyright © 1992 by Tudor Humphries

First U.S. paperback edition 1995

Library of Congress Cataloging-in-Publication Data

Allen, Judy.
Panda / by Judy Allen ; illustrated by Tudor Humphries.—
1st U.S. ed.
Summary: While on an expedition to western China with his father, twelve-year-old
Jake sees a panda but when he tries to take its picture the camera breaks
and no one believes his story.
ISBN 1-56402-142-4 (hardcover)—ISBN 1-56402-521-7 (paperback)
[1. Pandas—Fiction. 2. China—Fiction.] I. Humphries, Tudor, ill. II. Title.
PZ7.A4273Pan 1993
[E]—dc20 92-54411

2 4 6 8 10 9 7 5 3 1

Printed in Hong Kong

The pictures in this book were done in watercolor.

Candlewick Press
2067 Massachusetts Avenue
Cambridge, Massachusetts 02140

PANDA

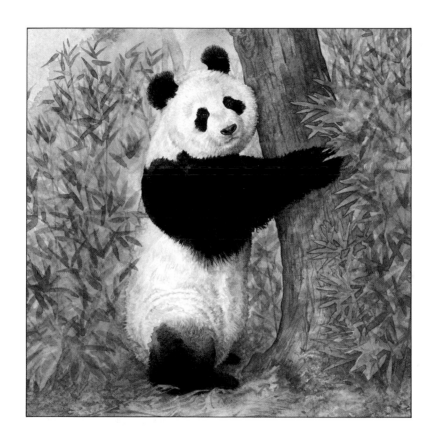

by
Judy Allen

illustrated by
Tudor Humphries

CANDLEWICK PRESS
CAMBRIDGE, MASSACHUSETTS

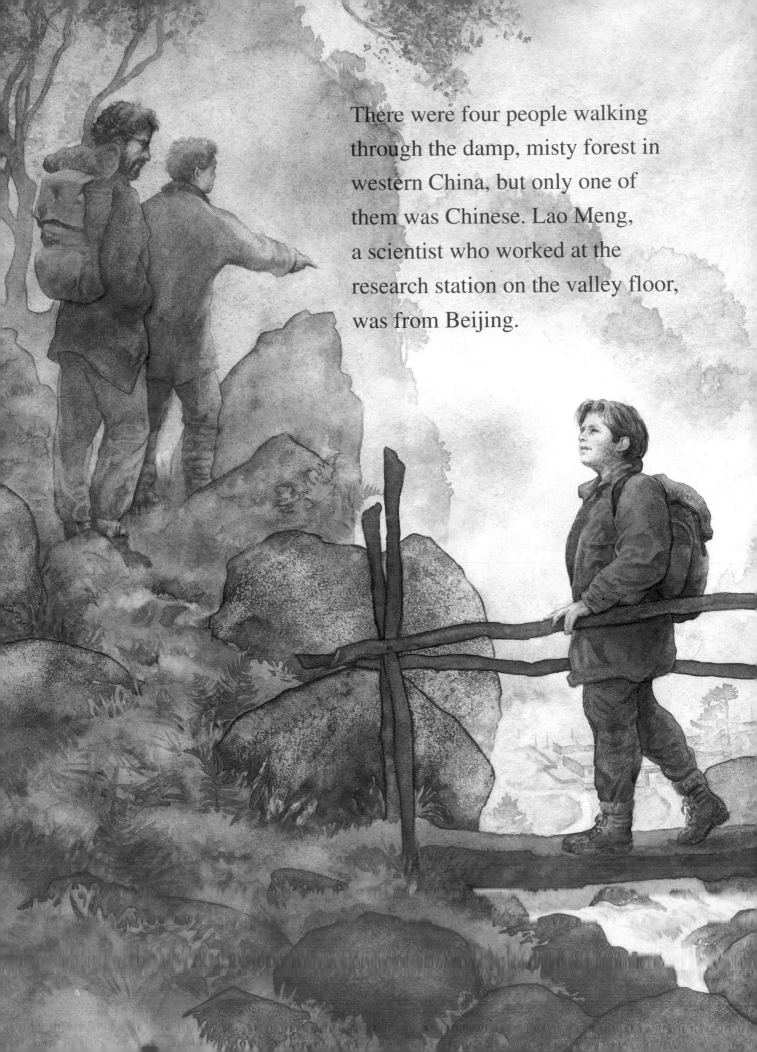

There were four people walking through the damp, misty forest in western China, but only one of them was Chinese. Lao Meng, a scientist who worked at the research station on the valley floor, was from Beijing.

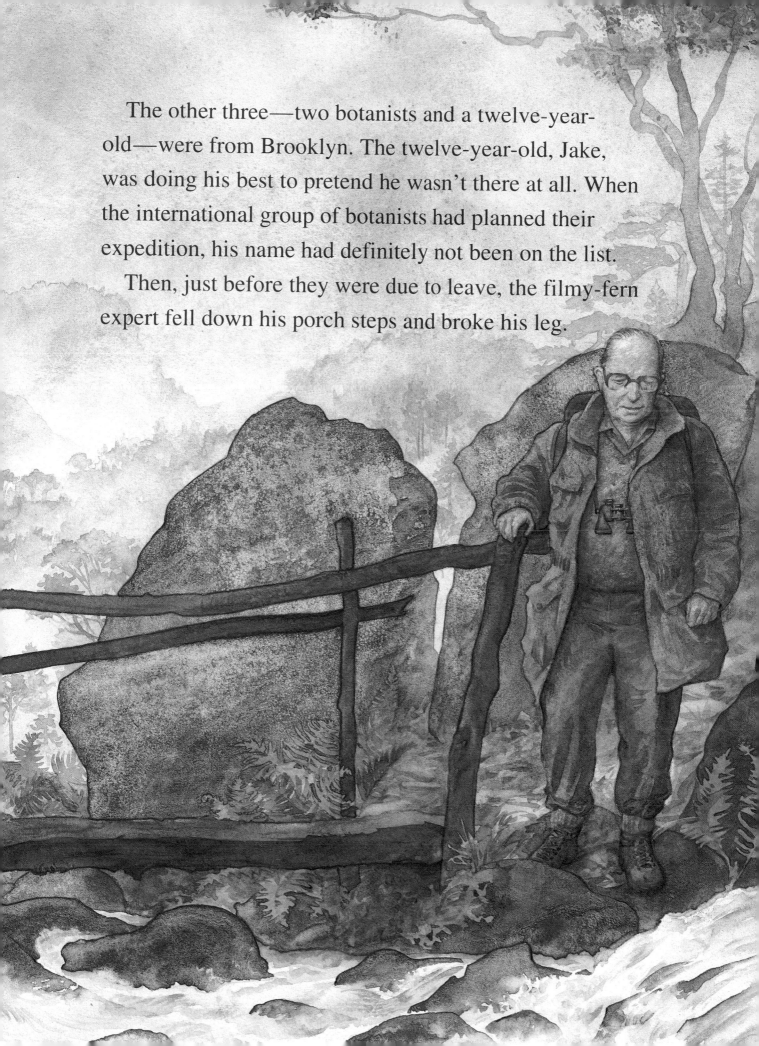

The other three—two botanists and a twelve-year-old—were from Brooklyn. The twelve-year-old, Jake, was doing his best to pretend he wasn't there at all. When the international group of botanists had planned their expedition, his name had definitely not been on the list.

Then, just before they were due to leave, the filmy-fern expert fell down his porch steps and broke his leg.

No one could be found to take his place so Jake's father—who was part of the team—suggested Jake.

Everybody was so surprised that they agreed, and it was not until the plane was in the air that one or two people began to have doubts.

"I hope I'm going to see a panda," said Jake.

"I hope you're not going to run around and step on rare specimens," said Professor Beall.

"I hope I'm not going to regret this," said Jake's father, who was Professor Beall's assistant.

So Jake was being extremely careful not to be a nuisance as they marched through the clammy undergrowth looking at special plants.

Today Professor Beall had persuaded Lao Meng to lead the three of them away from the main expedition to look for a rare species of orchid. The plan was that Lao Meng would leave them at a remote campsite, in the area where the orchids grew, and return to get them a day or so later.

As they walked past mossy-trunked trees, through wet ferns and grasses, and around tough thickets of bamboo, Professor Beall asked Lao Meng complicated questions about plants with Latin names. Lao Meng gave him complicated answers, but he still found time to point out things he thought Jake would find interesting.

Jake especially liked the dove tree, whose flowers hung from its branches like handkerchiefs.

Then Lao Meng showed him the bamboo, whose flowers were so small and pale they looked like shreds of cloth, caught on the stems by accident.

"You're here at the right time," he said. "This species only flowers once every ten years."

"Pandas eat bamboo, don't they?" said Jake, glancing

around, half expecting to glimpse a familiar black-and-white shape.

"They do," said Lao Meng, "and the flowering is bad news for them. As soon as the seeds drop, the plant dies, and it's a few years before the new plants are big enough for panda fodder. Luckily there are two different species of bamboo in this area, and the other one won't flower for some years."

He stopped suddenly. "Look!" he said. "Quickly! Across the valley there." He pushed his binoculars at Jake.

"What?" said Jake, taking them. "Is it a panda?"

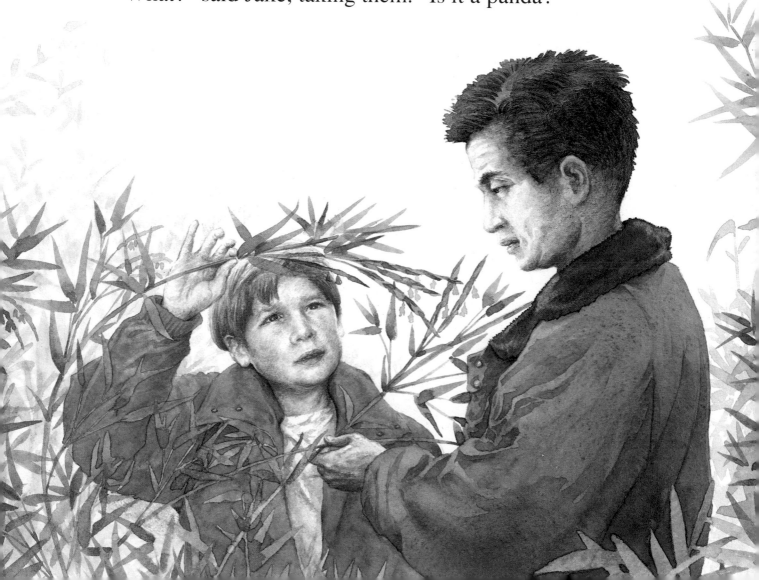

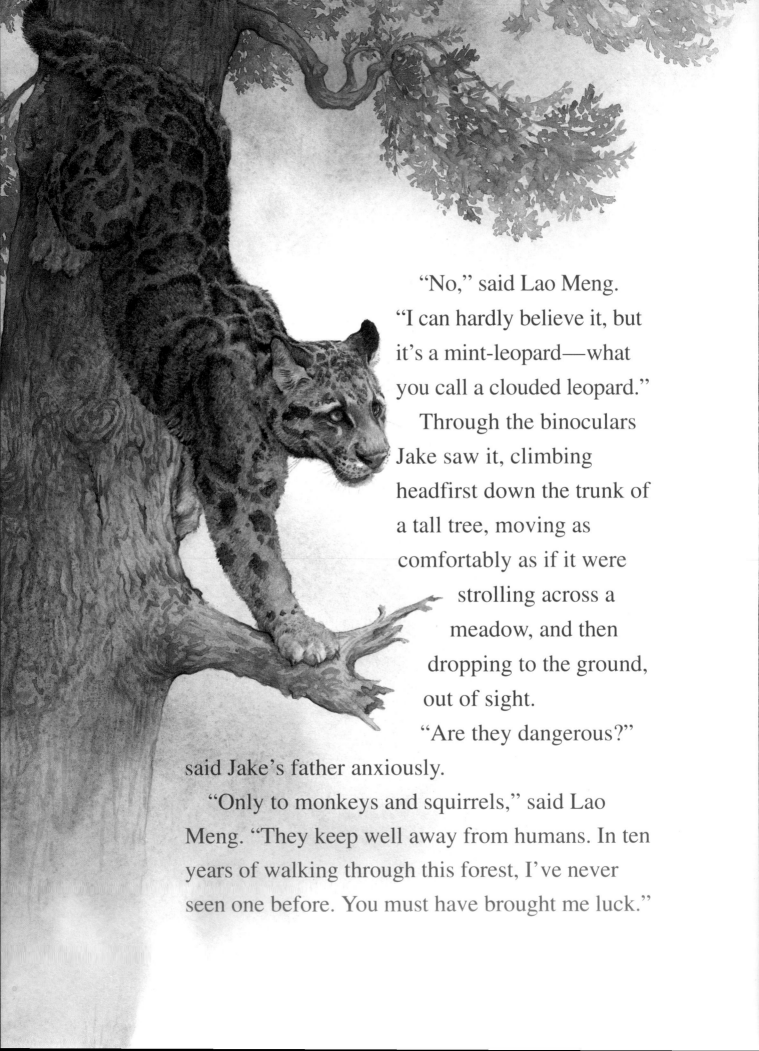

"No," said Lao Meng. "I can hardly believe it, but it's a mint-leopard—what you call a clouded leopard."

Through the binoculars Jake saw it, climbing headfirst down the trunk of a tall tree, moving as comfortably as if it were strolling across a meadow, and then dropping to the ground, out of sight.

"Are they dangerous?" said Jake's father anxiously.

"Only to monkeys and squirrels," said Lao Meng. "They keep well away from humans. In ten years of walking through this forest, I've never seen one before. You must have brought me luck."

Later he pointed out a bright orange-and-blue pheasant, which he said was called Temminck's tragopan, and a tiny shrew mole that they almost stepped on.

The campsite turned out to be no more than a clearing with a raised wooden platform. Lao Meng left as soon as he had helped put up their tent, and they ate supper as dusk fell, listening to the chirps and shrieks from the forest.

Professor Beall woke them early next morning, when the view from the tent was still all washed away by dawn mist. He wanted to leave at once to look for the orchids, which was what they had expected. What they had not expected, though, was that he wanted to leave Jake behind.

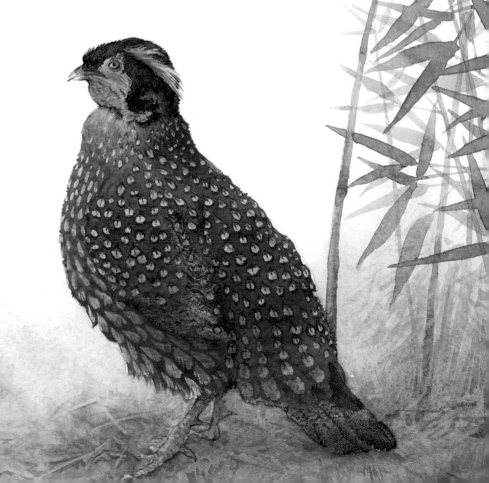

"We'll only be gone a few hours," he said, "and two of
us are less likely to tread on delicate plants than three of
us would be."

Jake was delighted. He'd had enough of plant hunting
and was quite happy to stay in the tent with his Walkman
and his favorite tapes. Jake's father was doubtful, but
Professor Beall soon persuaded him.

"He'll be safer here than he was in Brooklyn," he said,
as the two men left. "There's no one around, not even any
dangerous beasts."

It wasn't until midmorning that Jake decided to go for a
walk. Yesterday they had had the luck to see the leopard.
Perhaps today, he thought, he would have the luck to see
the one animal he had been dreaming about ever since
he'd joined the expedition. Ten minutes from the camp,

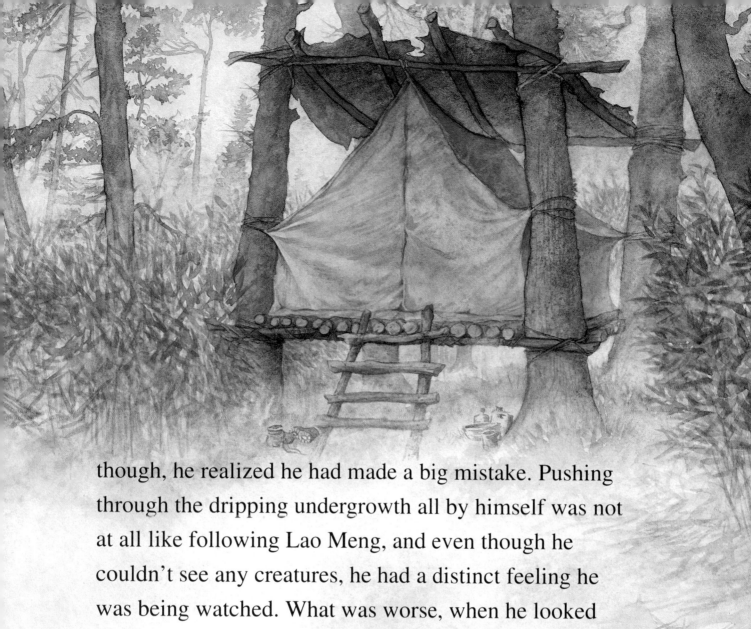

though, he realized he had made a big mistake. Pushing through the dripping undergrowth all by himself was not at all like following Lao Meng, and even though he couldn't see any creatures, he had a distinct feeling he was being watched. What was worse, when he looked back, the campsite had completely disappeared and for a terrible moment it seemed he was lost forever in a Chinese forest. He crashed back in what he thought was the right direction, hoping the noise would frighten off any clouded leopard who might be nearby.

But when he pushed past a stand of bamboo and saw the tent in front of him, he had a nasty surprise. Someone was inside. He could see the shadows of movement through the canvas walls—and when he stood still he could hear sounds, too.

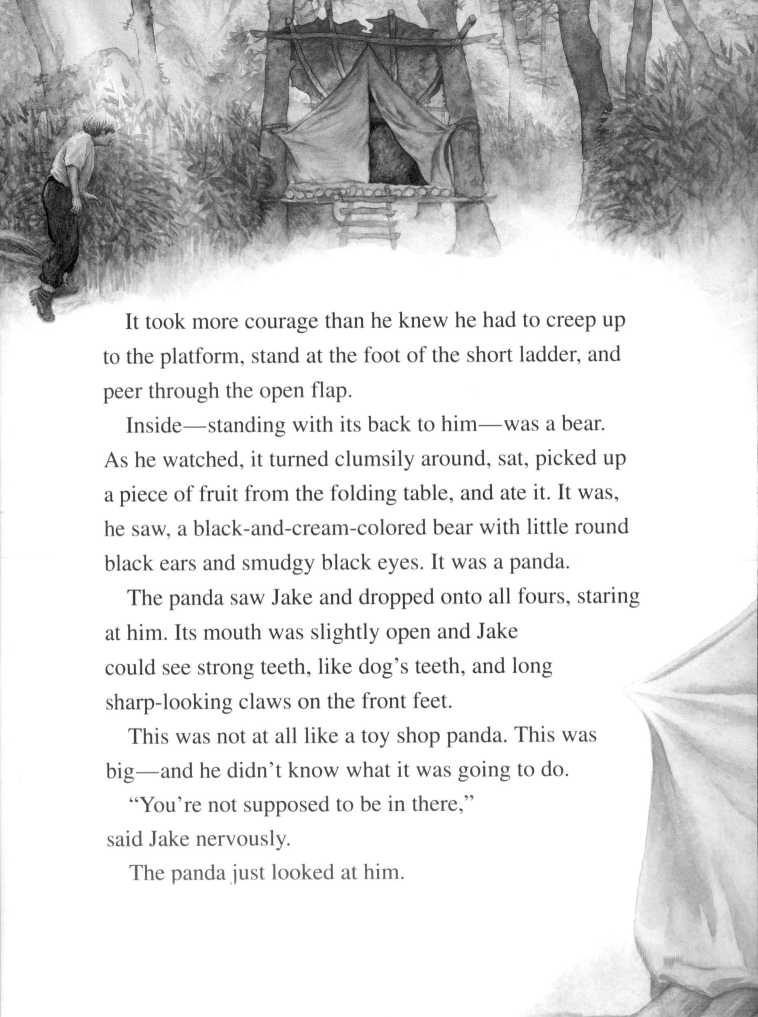

It took more courage than he knew he had to creep up
to the platform, stand at the foot of the short ladder, and
peer through the open flap.

Inside—standing with its back to him—was a bear.
As he watched, it turned clumsily around, sat, picked up
a piece of fruit from the folding table, and ate it. It was,
he saw, a black-and-cream-colored bear with little round
black ears and smudgy black eyes. It was a panda.

The panda saw Jake and dropped onto all fours, staring
at him. Its mouth was slightly open and Jake
could see strong teeth, like dog's teeth, and long
sharp-looking claws on the front feet.

This was not at all like a toy shop panda. This was
big—and he didn't know what it was going to do.

"You're not supposed to be in there,"
said Jake nervously.

The panda just looked at him.

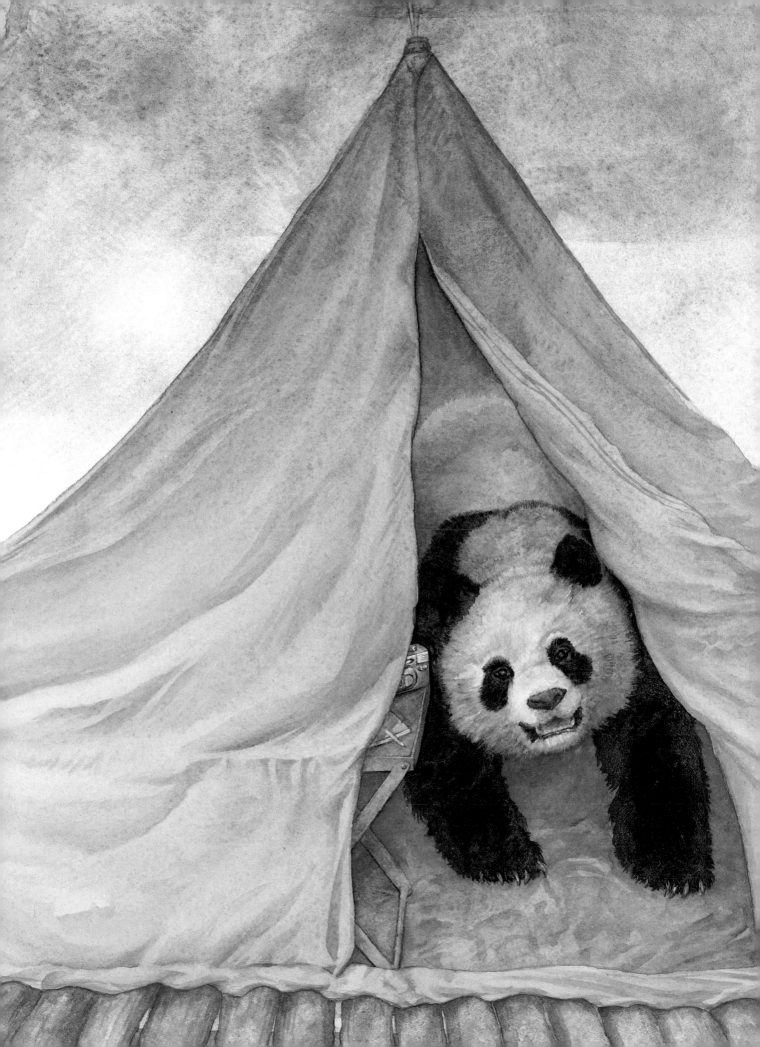

Jake thought he knew how to lure the panda out of the tent. He went back to the bamboo and picked some stems. They were tough and hurt his hands, but he got a good bunch and carried it back to the steps.

"Come and get it," he said, holding out a stem to the panda.

The panda sat down and continued to look at him. Jake crept closer, still holding out the stem. When he was near enough, the panda took the stem and ate it—grasping it in a hairy paw and turning its head to one side to chew on its back teeth.

Jake's plan to lure the panda out failed completely—instead, the panda lured him in by sitting where it was and reaching out for more bamboo. Jake went to and from the thicket several times. He felt like a waiter going to and from a restaurant kitchen.

After a while, the panda let Jake scratch it behind the ear with a long stick. Then it let him scratch it with his hand. It even turned slightly toward him and raised its arm so Jake could scratch a particular itch. Later it accepted the rest of the fruit and several crackers and even enjoyed the dried meat.

Jake sat beside it while it ate. It was big and calm and a little smelly, its coat much thicker and coarser than he had expected, its eyes quite small in their dark, smudgy surrounds. He couldn't believe it was neither frightened of him nor angry with him.

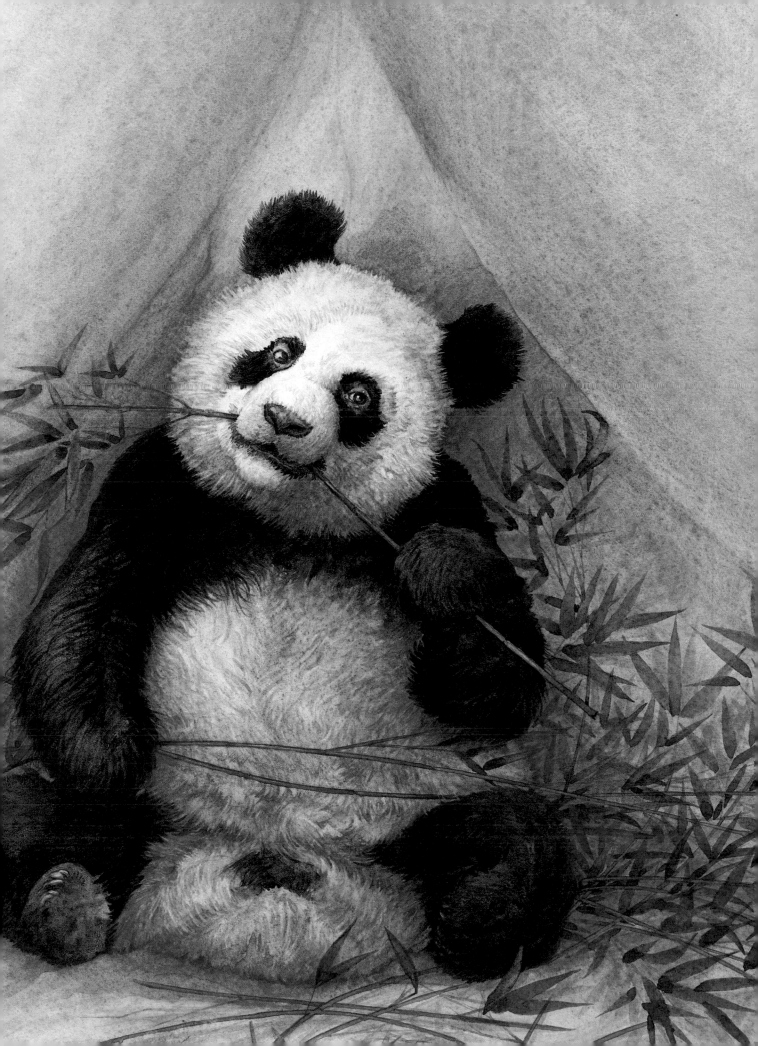

When it was full, the panda plodded over to Jake's sleeping bag. It raked it into a comfortable nest with its strong claws, turned around three times, then slumped down and sank into a deep sleep.

Thinking about it later, Jake decided he must have watched it for a good hour before he noticed that Professor Beall had left his spare camera behind. He could see it was an expensive one, but he felt sure the professor would want him to use it. After all, the panda might be gone by the time the two men returned.

The click from the shutter disturbed the sleeping animal, and it raised its head. When it heard the whirring of the auto-advance mechanism it got up and ambled through the tent. Jake put the camera on the table and stood aside.

Just as it reached the tent opening, the panda sat down heavily, half on the table, and scratched. The table collapsed and the camera fell.

The panda flopped down the three steps from the tent platform and plodded off into the forest, rocking a little as it walked.

"Thanks for coming," said Jake, and he meant it. Then he picked up the camera. It was jammed.

"Oh, rats!" said Jake, and he meant that, too.

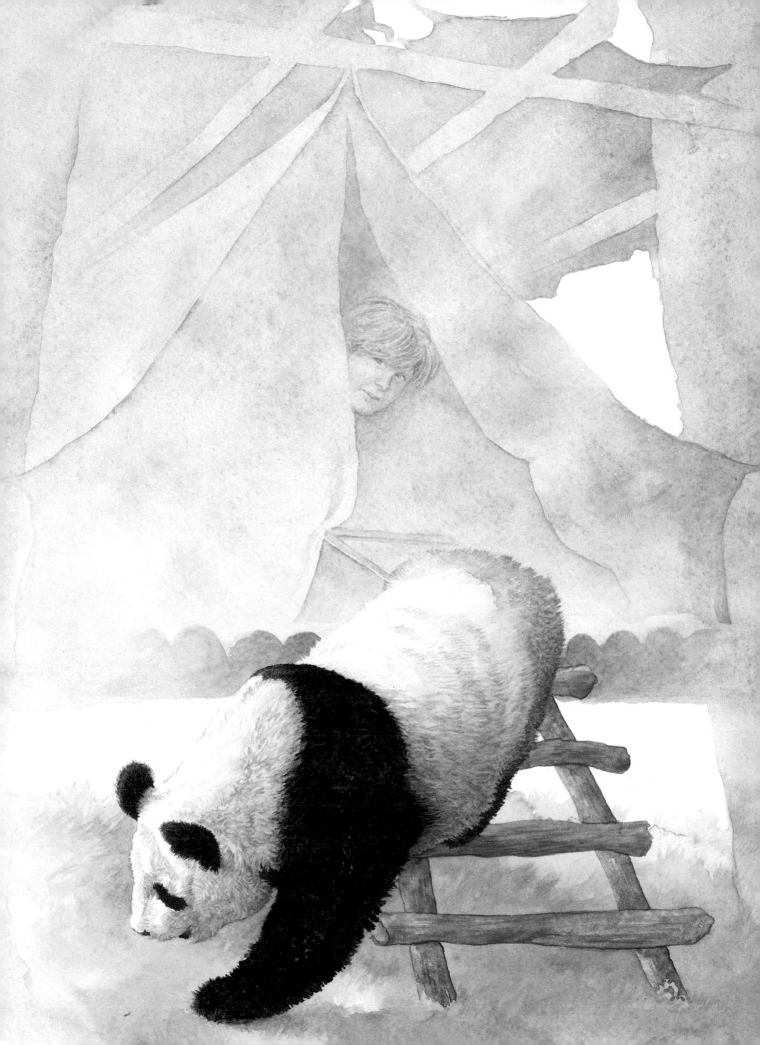

By the time his father and Professor Beall got back, grinning at the success of their orchid hunt, he had tidied his torn bedding and set the table on its legs again. But there was no way he could fix the broken camera, or replace the missing food.

They listened to Jake's extraordinary story. Then the professor shrugged and said, "Cameras can be mended— and most people eat too much when they're bored."

"You don't believe me!" said Jake, horrified. "But it *is* true."

"I don't think Jake would lie," said his father.

"He's not lying," said the professor. "He's just fantasizing. I blame myself for leaving him here alone all day with nothing to do." He sat down and began to sort through the specimens they'd collected. He was not grinning anymore.

Jake's father took Jake aside. "It's a good story," he said, "but you have to understand the professor deals in facts."

"Come and look at my bedding!" said Jake. "It's got claw marks and panda hair on it."

"I think we should eat soon," said the professor. He made it sound like an order.

Jake's father sighed. "It'll be a lot easier if you admit you broke the camera and apologize," he said.

In silence the three of them made a meal with what was left—a vegetable stew with rice. Jake took his a few yards away from the tent and sat on a fallen log. He stared into his bowl, not at all hungry.

"Maybe a camera shop can get the film out and develop it," he said at last. "Then I'll have the picture as proof."

The two men ignored him.

"Lao Meng will believe me," he said, "when he comes to get us tomorrow."

They didn't answer.

It was not very long before Jake heard the sounds of someone approaching through the forest. He listened, hopefully. Maybe that's Lao Meng, he thought, come back early. But what if he doesn't believe me, either?

The figure that appeared at the edge of the trees was not Lao Meng, though. It was shorter and stouter and very much hairier.

Three pairs of eyes stared as the panda approached to within a couple of yards of where Jake sat.

The panda looked at Jake.

Jake looked at the panda.

Then, very slowly and gently, Jake held out his bowl. The panda shuffled closer, sniffed, then sat back on its haunches, took it in its paws, and drank the stew.

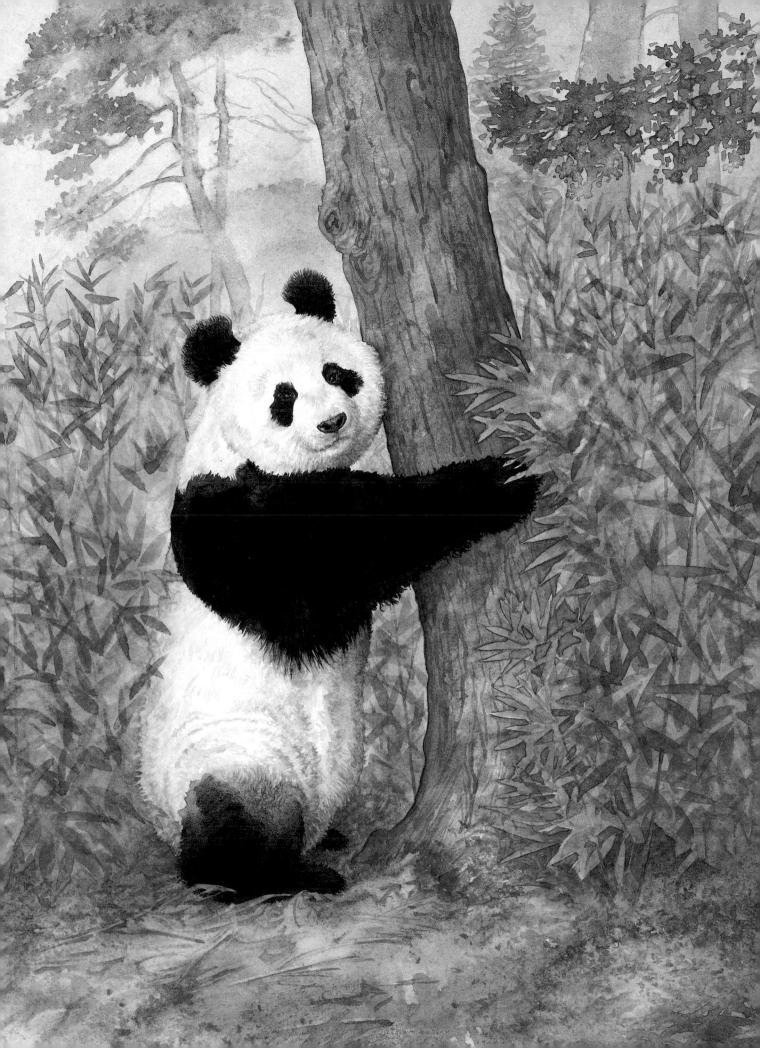

Then it licked the bowl thoroughly, inside and out. Nobody said a word. Nobody moved.

When the panda had finished, it dropped the bowl, rolled forward onto all fours, and shambled slowly off into the trees.

There was a silence that lasted for several seconds.

Then Professor Beall said, very quietly, "We have had an honored guest."

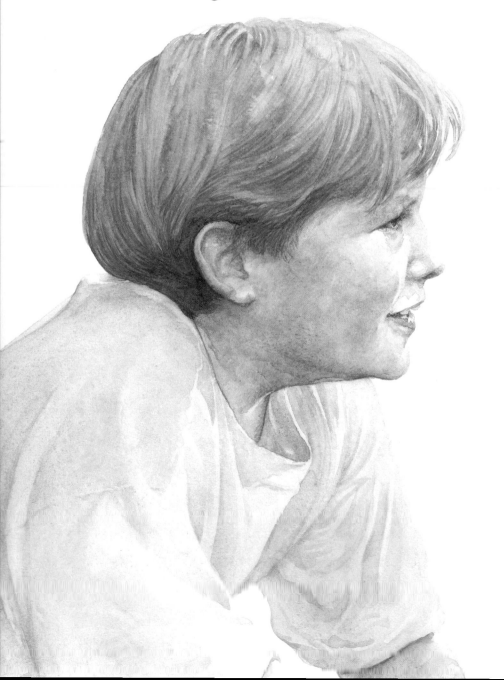

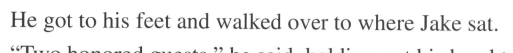

He got to his feet and walked over to where Jake sat.

"Two honored guests," he said, holding out his hand to him. "Please forgive me, Jake."

"Jake," said his father, following behind the professor, "Jake, I'm sorry— I apologize."

"That's okay," said Jake. "But I still hope my picture comes out. You both forgot to take one."

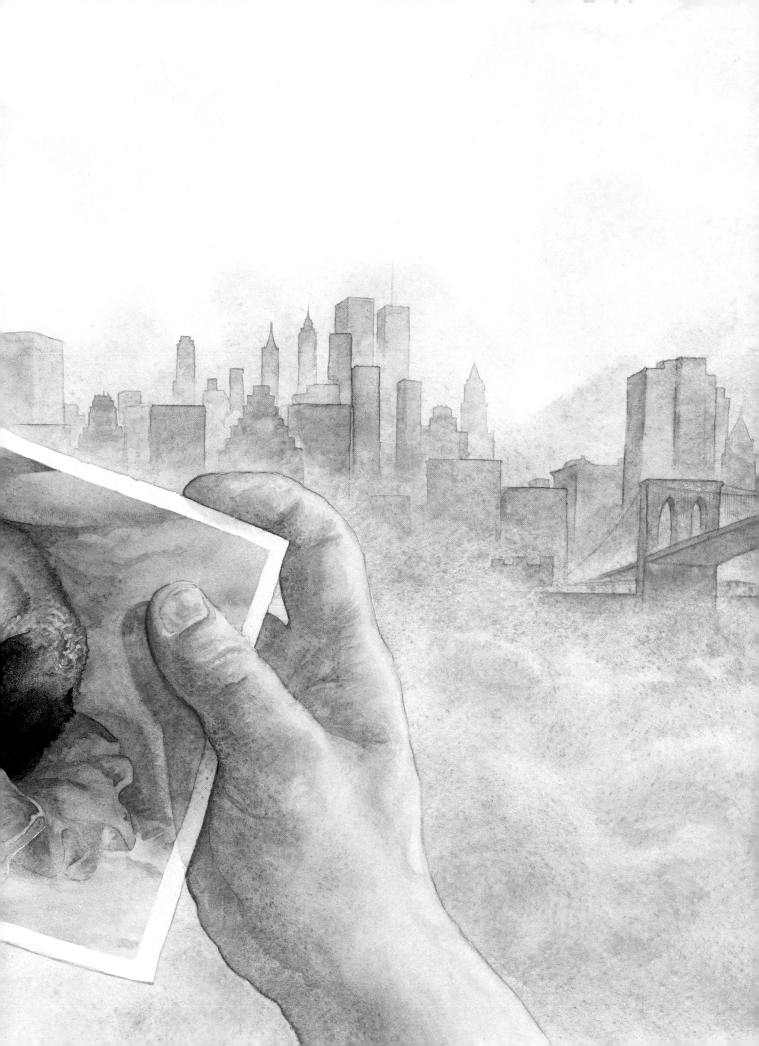

PANDA FACT SHEET

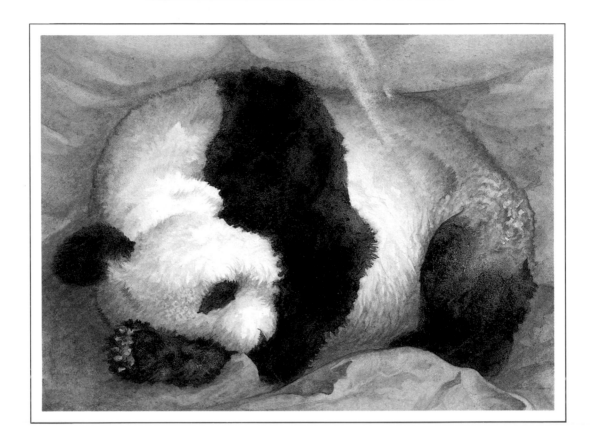

The giant panda is perhaps the best known and most loved of all rare animals. About one thousand of them survive in the rainy hills of southwest China, in the provinces of Sichuan, Shaanxi, and Kansu. Here the pandas feed on various sorts of bamboo that grow in dense thickets on the hillsides.

WHAT ARE THE DANGERS FOR PANDAS?

At intervals ranging from 10 to 100 years, each kind of bamboo that the pandas eat flowers all at once and then dies off after it has produced its seeds. This leaves the pandas with very little to eat until

new bamboo plants have grown. In the past, the pandas would move to other areas to find bamboo that was not flowering. In recent years, though, people have cut down so much bamboo to make spaces for their homes and their crops that many pandas die of starvation. In addition, pandas are sometimes trapped for their skins, which can be sold for very high prices, or are accidentally caught in snares that poachers have set for other animals.

IS ANYONE HELPING PANDAS?

Yes. The Chinese government has made it illegal to kill them, and has turned most of the areas where they still live into national parks and reserves. Since 1980 World Wildlife Fund has worked with the Chinese government to try to develop a plan to better protect pandas.

ARE EFFORTS TO SAVE PANDAS SUCCEEDING?

Up to a point. Their population is slowly decreasing, and scientists worry that current conservation efforts may not be enough to ensure that the species survives. Pandas prefer to live solitary lives, their courtship rituals are complicated, and the female usually has only one cub. This means that the pandas that die from starvation, trapping, or simply old age are not replaced very rapidly. There is a lot more work to do before anyone can say for certain that the panda is safe.

For more information about pandas and what's being done to save them, write to:

World Wildlife Fund
1250 24th St. NW
Washington, DC 20037

JUDY ALLEN has written many books for children, including *Whale, Tiger, Elephant, Eagle,* and *Seal,* each story dramatizing the plight of an endangered animal. She notes, "Pandas can be unpredictable and dangerous, but there's something comforting about them. That's why the story ends the way it does—with the panda's return bringing about the resolution of the story."

TUDOR HUMPHRIES has illustrated all of Judy Allen's books about endangered species. He says that in the book, "we wanted to get away from the cuddly toy image of the panda and make children aware of it as a naturally wild animal." He adds, "I love illustrating Judy's books because her stories are about the magic that exists where the real world meets the world of possibilities."

**More books by
Judy Allen and Tudor Humphries:**

Eagle

Elephant

Seal

Tiger
A *READING RAINBOW* SELECTION

Whale